Typography!

The Ultimate Beginner's Course To Eye-Catching Type For Print, Graphics, Web Designers, Developers And Students

Introduction

For many graphic designers, Typography is a fascinating world on its own. Looking at various Types or Letterforms, we can definitely see that each of them is an exquisite work of art. Apart from being beautiful, Types or Letterforms also comprise the most basic form of our literature. They form words, sentences, and thoughts.

Typography basically is the foundation of our history. Without the various Letterforms of Typography, none of us would be able to communicate through basic text with one another. Typography allows us to pass on every aspect of our experiences from one generation to the next. Look around and you'll definitely see that Typography is all around us.

One can say that Typography involves various practices, traditions, functions and is considered by many as a language on its own. Typography plays a crucial role in various forms of observable media. The aim of this book is basically to give you a good foundation in Typography essentials.

If you happen to be a graphic designer who is looking to create a brand identity or a website

developer creating an attractive website for a local business perhaps, this book definitely has a lot in store for you. There will be countless materials in this book that will give you a better grasp of the basics of Typography. In addition, this book will also help you make better decisions with regard to Typographic usage.

For Typography veterans, this book will definitely serve as a good refresher and may even provide you with new practices and ideas that will further improve your Typographical usage. With this book you'll be able to delve into the classic principles of Typography. In addition to that, this book will also discuss various Typography practices in more detail. The detailed discussion in this book will give you a better sense of why the various practices work the way they do.

All-in-all, this book will ultimately help you make the best typographical design choices for your various design projects. So sit back and enjoy this book and allow us to take your hand as we explore the Foundations of Typography.

Chapter 1: Why good Typography is Crucial

Typefaces in Typography are crucial since they provide viewers that vital first impression about a message. The amazing thing about it is that the first impression is perceived by the viewer even before they even start reading the message. As an example, a Type can clear depict whether a message is aggressive or passive. It may also suggest a modern or classic approach.

Type can also represent masculinity or femininity. It can express serenity or chaos. As a disciple of graphic design, it is imperative that you select a type style that best depicts that message that you want to convey. Whenever type is utilized properly, a positive impression is immediately perceived by the viewer.

Also, the key contents of a message are almost immediately absorbed by the viewers whenever the correct type is used. Today, we live in a culture where everything is visually driven. People tend to be more visually inclined these days. Even those who are not adept in Typography can sense the subtle differences between a well utilized Type and one that is used recklessly.

People have become so visually inclined that even thought they can't explain why they have a negative impression about a design, they can still feel that there's something off about it. Many big companies spend millions of dollars, trying to formulate the right corporate identity and typographic branding. Why? Because they recognize Typography's most important aspect; it's personality.

Because of typography's personality, it is able to make an impression. Just like a human being, typography's various types can incite an emotional reaction from the viewer. Therefore, it is safe to say that in every situation, a clean, good and well utilized typography can make a huge difference.

The Influence of Type

Type is crucial because it is the conveyor of information. It is a mode of delivery that does more than convey. Good type choices can also improve the message it conveys, making it more accessible and readable to the viewer. Typography is all about looks; the visual aspect. Type's primary aim is to visually convey its message.

Let's discuss examples that show how type can mean the difference between life and death. Two common examples are Prescription medicine

prints and Roadside Signage. Roadside Signage has to be clear and legible enough so that it can be read by the passing motorists. Not only should the letterform be clear and legible, it must also be large enough that it can be read by a motorist going at 60 miles an hour and from a particular distance.

Both of these are crucial so that one can make timely decisions on the road. In addition to the aforementioned, letterforms should also be readable under adverse environmental conditions. Imagine that you're driving along the highway at night, going 60 miles an hour while it is raining hard. The information on the highway signage must be clear, large and legible to the driver even during worst conditions. Putting a clear and large letterform on a roadside signage could mean the difference between a roadside accident and driving home safely.

The next example is the print on a Prescription medicine bottle. We've all seen how tiny prescription medicine bottle prints are. These tiny bottle prints are often the reason why some people take the wrong medicine. Many people are having a hard time reading the small print, especially for older people who are visually impaired.

Because of this dilemma, a graphic designer named Deb Adler was motivated to remake the letterforms on prescription medicine bottles. She wanted to make them more legible and easy to understand after her grandmother mistakenly took the wrong medicine and became seriously ill. She redesigned the whole labeling scheme, increased the size of the type and utilized a much clearer typestyle. After implementing the redesigned labeling scheme, the number of people who take the wrong medicine because of misreading the label was drastically reduced.

It is clear that correct typographic usage could mean the difference between life and death. Contrary to what some people are saying, good type utilization is not just about artistic taste. Correct type usage is a matter of legible and strong communication.

Typographic relativity

There's a vital typography concept that many novice and non-novice graphic designer should know about. It is called the role of proper proportions. Most people also know this as the Typographic Relativity theory.

The Typographic relativity theory basically applies to each and every design that is created using type. It discusses the correlation and interaction between each and every typographic

element. An extremely successful graphic design has many parts and those parts are all related to one another. Just imagine for a second that you are going through a recipe to prepare a meal. If you decide to change the proportion of one of the main ingredients in the recipe, logic dictates that you have to change the proportions of the other ingredients as well.

A recipe's overall taste is determined by the correlation of all of its ingredients to one another. Looking at it outside the box, each ingredient has a significant impact on every other ingredient in a recipe. Another great example would be the feeling that you obtain when you enter an exquisitely designed room or area. You get a sense of great comfort from the proper allocation of space in a room. In addition, the room's various elements such as color, surface, shape, accessories, lighting and furnishing all appear to go together harmoniously.

It is not by chance, nor is it by accident. It is the overall result of proper decision-making and getting a grasp of how each and every aspect interact with each other. Typography is like that as well. Various typographic elements correlate with one another.

They must strike a balance with one another in terms of size, position, weight and orientation. On top of that, typographic elements such as colors, styles, etc. must be balanced so as to communicate the design's intended message to the viewer. Remember, everything in your design project exists in relation to all other aspects. That is what the Typographic Relativity Theory is all about.

Chapter 2: Typographic Distinction

In Typography, there exist two basic categories of letterforms. These are Serif and Sans Serif. Let's discuss the distinction between the two styles.

Serifs

SERIFS

serifs

Serifs are the most common type of letters. They are characterized by little feet or extenders. Below is a group of widely used Serif typefaces.

Baskerville	Georgia
Big Caslon	Goudy Oldstyle
Century	Adobe Jensen
Cochin	Modern No. 20
Courier	Palatino
Didot	Times New Roman
Garamond	Warnock Pro

As you can clearly see, the above group of typefaces is different from one another in terms of strokes. The one aspect that is prevalent among them is that they're all Serif letterforms or typefaces. Another discernible characteristic of a Serif typeface is the serif at the bottom of the letters called footers.

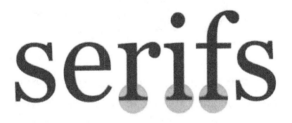

What we discussed so far are Serif typeface similarities. Now, let's take a look at some Serif typeface differences. At this point, it doesn't matter whether you're able to discern which

Serif typeface is which. What's important is you know what telltales to look for when you're looking at a typeface. Below are five lowercase letter Ls from five different Serif typefaces.

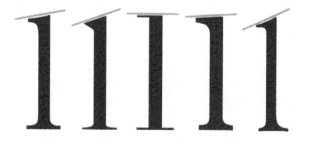

Let us look closely at some of the specific distinctions between them. As you can clearly discern from the example, the serif angles vary slightly from typeface to typeface. The same thing can be said about each typeface's footers.

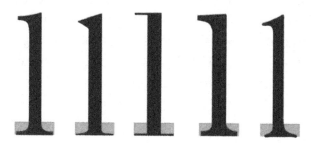

It is clearly evident that the footers' width, shape, and thickness are varied. Looking at the

Serifs at the top, you can see that the thickness, width and shape are varied as well. We're looking at these minute details at an enlarged scale, but keep in mind that these minute details are crucial, because they greatly impact how the typeface looks when scaled down to a suitable reading size.

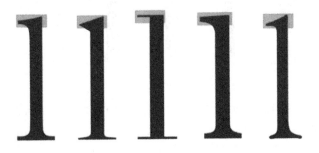

The next thing that we will discuss is the disparity between two major broad categories of Serif, the Unbracketed and Bracketed Serif. As you can see from the illustration below, the Unbracketed Serif exhibits a sharp 90 degree cornered angle. The Bracketed Serif, however, have a curved Serif to stand progression.

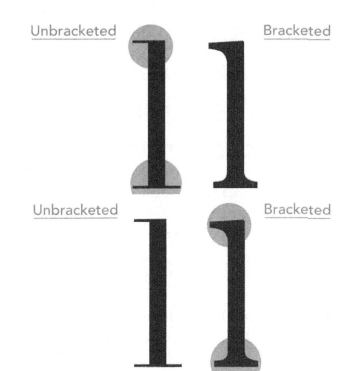

Unbracketed · Bracketed

Unbracketed · Bracketed

Another category of Serif that warrants discussion is the Slab Serif. Pay attention to the differences of the various Slab Serif font examples below.

American Typewriter
ITC Lubalin Graph
Memphis
Rockwell
Serifa
Stymie
Vitesse

Variations in details and letter widths can be clearly observed, but there's one commonality between all of them. Their Serifs, their horizontal strokes, exhibit the same width or height as their vertical strokes.

Sans Serifs

SANS SERIF

Let us now take a closer look at the Sans Serif. In contrast to Serifs, Sans Serifs are letters without the little feet. Sans is basically a French word for "without". Therefore, Sans Serif means without Serifs; without feet. In the graphic design world, Sans Serifs are just called "Sans" for short. Below are some commonly known Sans Serif typefaces.

Century Gothic **Kabel**

Eurostile Myriad

Franklin Gothic News Gothic

Futura Optima

Gill Sans Skia

Helvetica **Stone Sans**

Interstate Verdana

As you can see, the given examples are clearly distinct from one another. One common thing exists between them, however, and that is they don't have feet; no serifs. So now you possess the expansive stokes of type categorization. We will do an in-depth discussion on type categorization as we go along in this book.

There are tens upon thousands of typeface variations in each of these categories that are readily available from many font foundries and type sellers out there. You'd be amazed that even graphic design veterans aren't even familiar with all of them. However, if you can gain the ability to discern the crucial variations and characteristics of basic type styles, it will definitely help you make smart, educated

choices in your graphic design projects. Learning to distinguish between the various types of Serifs and Sans Serifs is the first step.

Being able to distinguish between Display Type and Text type is crucial in typography. Here's what you need to keep in mind.

Text Type

Text type is a type of letterform that is specifically made to be read at small sizes in large quantities. This is the type of text that you would normally see comprising the paragraph of an article or document. The bulk of text that you will find in any magazine, book, newspaper, brochure, etc. is Text type. Another common term for Text type is Body Copy or Body Type.

The typical size of a Text Type is around 8 to 10 point size. There are certain applications where the Text Type point size is 12. Text type point sizes will again depend on the typeface being used. Due to its small size, Text types have to be very easy to read.

TEXT TYPE

Text type is designed to be read in large quantities at small sizes. Text type is designed to be read in large quantities at small sizes. Text type is designed to be read in large quantities at small sizes. Text type is designed to be read in large quantities at small sizes. Text type is designed to be read in large quantities at small sizes. Text type is designed to be read in large quantities at small sizes. Text type is designed to be read in large quantities at small sizes. Text type is designed to be read in large quantities at small sizes. Text type is designed to be read in large quantities at small sizes. Text type is designed to be read in large quantities at small sizes. Text type is designed to be read in large quantities at small sizes. Text type is designed to be read in large quantities at small sizes. Text type is designed to be read in large quantities at small sizes. Text type is designed to be read in large quantities at small sizes. Text type is designed to be read in large quantities at small sizes. Text type is designed to be read in large quantities at small sizes. Text type is designed to be read in large quantities at small sizes. Text type is designed to be read in large quantities at small sizes. Text type is designed to be read in large quantities at small sizes. Text type is designed to be read in large quantities at small sizes. Text type is designed to be read in large quantities at small sizes. Text type is designed to be read in large quantities at small sizes. Text type is designed to be read in large quantities at small sizes. Text type is designed to be read in large quantities at small sizes. Text type is designed to be read in large quantities at small sizes. Text type is designed to be read in large quantities at small sizes. Text type is designed to be read in large quantities at small sizes. Text type is designed to be read in large quantities at small sizes. Text type is designed to be read in large quantities at small sizes. Text type is designed to be read in large quantities at small sizes. Text type is

During the 1930s, a very famous typographer named Beatrice Ward wrote a remarkable essay about text typography. In this essay, she metaphorically related a crystal goblet to typesetting. She stated that the goblet should be clear as crystal in order for the content to be seen first, instead of the goblet itself. The main point of her essay was clarity in typesetting makes the content easy to acknowledge, implying that typography or printing should be inconspicuous.

The goal is to have a smooth reading experience. When we're in the process of reading, things may seem seamless. But in actuality, we depend on countless small visual cues to assist us in absorbing the words and small blocks of text in a fraction of a second. Letterforms need not be an

obstacle in this seamless reading process. Letterforms need to be clear and legible so that the reader makes no conscious effort whatsoever to acknowledge the shapes of the letters.

Text typefaces, which are designed to be read in huge volumes in minute sizes, share some common important traits. Looking at the examples below of common Text typefaces, you will notice that each type has open spaces inside the letters.

Text typefaces have common characteristics
ADOBE CASLON PRO

Text typefaces have common characteristics
BASKERVILLE

Text typefaces have common characteristics
ADOBE GARAMOND PRO

Text typefaces have common characteristics
PALATINO

Each letter body height is tall, compared to the capital letters. They are of medium weight and exhibit repetitive and rhythmic outlines. Due to the aforementioned characteristics and details, the letters are easy to distinguish. Most text typefaces of today are just digitized versions of

typefaces that have been used hundreds of years ago because they work absolutely well to this day. The first three typeface illustrated above are good examples of these.

Display Type

In contrast, Display Type is a type of letterform that is designed to be read in small quantities at large sizes. Display Type is usually 14 point or larger and is commonly used for effect and emphasis.

DISPLAY TYPE

Display type
is designed
to be read in
small quantities
at large sizes.

Most of the 200,000 readily available typefaces are Display Types. They are used in almost all design projects today. Display Type is the total

opposite of Text Type. It relies on its uncommon form to denote and extend its content.

Unlike its Text Type counterpart, Display Type is not designed to be inconspicuous; invisible. It is designed to catch attention. In the vast pool of various typefaces available out there, there exist a specific Display Type for every possible use. For example, if you're looking for typefaces that resemble handwriting, tens of thousands of typefaces are readily available. A few examples of these are illustrated below.

handwriting typefaces

handwriting typefaces

handwriting typefaces

handwriting typefaces

handwriting typefaces

There is one other important thing to remember between Text Type and Display Type. With Text type, they can be converted into Display Type by making their point size larger. Display Types,

however, cannot be reduced in size to function as Text Type.

Chapter 3: Classifications of Types

In this chapter, we're going to take a closer look at some details and shapes that will assist us in classifying typefaces, apart from just serif and sans serif. All currently recognizable typefaces belong to a known tradition. In order for graphic designers to make knowledgeable decisions about correct typeface utilization, we have to pinpoint typefaces according to their historical backgrounds.

Despite not having a single all-encompassing system of type classification, we would like to familiarize you to the basic and most widely identified classifications of type. The first and the most basic serif type are called Oldstyle. Oldstyle, which is of Roman origin, was created somewhere between the late 15th century and middle 18th century.

OLDSTYLE

Below are some examples of Oldstyle typefaces. Look at how they have minimal contrast between thin and thick strokes coupled with serifs that are bracketed.

Caslon
Sabon
Bembo
Garamond

Oldstyle typefaces have noticeably long descenders and ascenders. Descenders and Ascenders are letterform parts that stretch beyond the top and bottom of the body height. In addition, the spaces within the body of each letter are small. The second most basic category of type is called Transitional.

TRANSITIONAL

Baskerville
Bell
Bulmer
Georgia

The Transitional typeface serves as an eloquent link between the Oldstyle typeface and the next typeface class called Modern. The most discernible characteristic of Transitional typeface is their tighter bracketed curve. In addition, the stress of each curved letter is more vertical. You will also observe the imaginary line that connects the thinnest parts of the letter "O" called the stress.

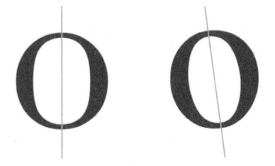

There exists a higher contrast between the thin and thick strokes of a Transitional typeface. During the mid 18th century, advances in font and print technology led to the change in typeface appearance from Oldstyle to Transitional. During the late 18th century, Modern typefaces made their initial debut. Modern typefaces are easy to spot.

Notice the existing contrast between the slim and wide strokes and the excessively thin unbracketed serifs, which are horizontal.

Bodoni
Didot
Modern No. 20
New Caledonia

The third major basic serif type is Slab Serif. It too emerged during the mid 18th century. Because of the Slab Serif's strong presence and weight, they were mainly used for signage and advertising. You will notice that with the Slab Serif, the serifs are also basically unbracketed.

Rockwell

Memphis

Serifa

Vitesse

In addition, Slab Serifs exhibit inadequate contrast between strokes. What that means is that the thicks and thins of the strokes are of equal weight.

Refusing to be outdone by the other Serif types, Sans Serif typefaces also matured to accommodate the needs of advertising. This maturity or evolution brought about three main classifications of Sans Serif typefaces:

Grotesque – Gothic is another term by which Grotesque goes by. They exhibit modest disparities in stroke width. Looking closely at Grotesque or Gothic sans serif, you will notice that the letters are adequately spacious and the rounded letters are a little bit squared off.

GROTESQUE SAN SERIFS

News Gothic
Helvetica
Univers
Verdana

Humanist Sans Serif – This type of Sans Serif have a characteristically distinct classical Roman letter proportion. Upon closer scrutiny, you'll notice some of the dimensions of the hand-lettered Roman forms.

Gill Sans
Myriad
Optima
Frutiger

Geometric Sans Serif – Out of the three categories of Sans serif, the Geometric Sans Serif is the easiest to detect. This is due to the basic geometric forms it is based off, which is the circle, triangle and square. Geometric Sans Serif resonate the modernistic movement of the 20th century. Some of the widely known Geometric Sans Serif are the Avant-Garde, Kable and Futura.

Futura
Kabel
Century Gothic
Avant Garde

Today, newly created typefaces that follow the design pattern of a type classification are also included under that particular category. These types of typefaces are commonly known as Revivals. Remember, understanding the various type classification will definitely help you select which kind of typeface to utilize for your graphic design project.

Now, were going t o take a look at some types of typefaces that don't fit perfectly into the aforementioned classification categories. These typefaces are all Display Type. Therefore, keep in mind that they should only be utilized at bigger sizes and in minute quantities. There are basically two typefaces that fall under the "other" category:

Scripts – This typeface is easy to distinguish because of its popularity. Scripts are letterforms that are based off of handwritten letters. The

main thing people notice about scripts is that they are linked to one another with connecting strokes. Below are some common examples of scripts that vary from being informal to very formal.

Edwardian Script

Snell Roundhand

Dorchester Script

One type of script that many designers use in their design project is the Bickham Script. It is preferred by many designers because it is exquisitely elegant. In addition, its character set is also comprised of hundreds alternate flourishes. Looking at the example illustration below, the Bickham script has 15 possible variations of the letter H in lowercase.

h h h

h h h

h h h h h h

h h h

Scripts are very famous, hence they can be seen everywhere. There are informal scripts that may look like brush written or handwritten letterforms. Today, there exists hundreds if not thousands of wonderful scripts with varying degrees of fluidity, alternate characters and weight.

There are scripts that can also be tricky to use. An example of this is the Zapfino script. They are tricky to use because they sometimes have huge swashes which can get twisted up when lines are unsymmetrical.

Zapfino needs

space to spread out or

it can get tangled

Blackletter or Fraktur – This is the other typeface that falls under the "other" classification. As you can see from the illustration below, this typeface does indeed look like they are broken or fractured. Their fractured or broken look can be attributed to the individual strokes that comprise each letter in this typeface. Similar to scripts, Blackletters or Frakturs also have an array of typefaces to choose from.

Blackletter
or fraktur

Among the hundreds of Blackletter typeface variations in existence, the Fette Faktur is what most graphic designers favor. The spiky nature of the letters in this typeface is the reason why some people call this letterform Old English.

Wilhelm Klingspoor Gottisch

Wittenberger Fraktur

Fette Fraktur

juicy!

In the example illustration below, you will see why these typefaces are given the name Blackletter.

Looking at the illustration above, Blackletters are called as such because they possess a weighty appearance, there is little to no space between individual letters, the spaces within each letter is very minimal and the spacing between each line is extremely tight. Because of this, their overall hue on the page is black. Beyond Scripts and Blackletters, there exists a plethora of ornamental and decorative typefaces that were created to accommodate the needs of promotion, advertising and brand identity.

Some of these outrageous and extraordinary typeface styles justify categorization. Many typography veterans regard Display typography as having a volatile nature, similar to the unpredictable winds of fashion.

Skimming through the never-ending type choices available today might prove to be a daunting task. However, the more you look at type with a savvy and keen eye, the more knowledgeable your view becomes. In the end, you will establish a deeper perception of what to search for. This will definitely help you acquire a display typeface that will match your particular needs.

Chapter 4: Typeface Combination Guidelines

Due to the huge selection of typefaces available out there today, the most common rookie question that gets asked around is how does one know which Typefaces match? In this chapter, we will be taking some of the enigma out of making good typeface choices. We will be looking for a good harmonious mishmash of typefaces. Remember, using too many Typefaces at once can create visual chaos.

A good rule of thumb when combining typefaces is you're better off choosing one Typeface which has a good number of variations. A good example of this is the Helvetica Neue font. The Helvetica typeface family is broad and has varying widths and weights. Each Helvetica family even has matching italic letter sets.

Helvetica Neue Thin

Helvetica Neue Ultra Light

Helvetica Light

Helvetica Neue Roman

Helvetica Neue Medium

Helvetica Neue Bold

Helvetica Neue Heavy

Helvetica Neue Black

Since the fonts all come from one family member, you can be rest assured that the other family members will play well together. But let's say that the need for you to use more than one Typeface cannot be avoided. Here are some elements that may help you make up your mind which typefaces to choose:

Contrast or Differentiation – This most common factor or element will help you determine which typefaces go well together. A common setting would be headlines and body text. The most common Text type choice for most designers is a Serif typeface. So for contrast, you would most

likely want a Sans Serif typeface for the headline due to its variety of bold weights.

Most design projects rarely need more than two well-picked Typefaces to make a broad and effective typographic hierarchy.

Basic Characteristics – When combining various typefaces, one must also consider a typeface's basic attributes. There's a likelihood that typefaces that come from a similar time period but whose families have variations in features, may work good together. Another effective approach is to use typefaces that come from the same designer, since they have a similar "stylistic connection". You may also try to combine two extremely opposing Typefaces, one very classical and moderate, the other, cordial and warm.

Typefaces that have the same body height can be effectively combined together as long as their styles clash enough to create a bulky contrast; but not too much that it'll create visual cacophony. Many designers make the mistake of putting together Typefaces that are both individually distinctive. Their Stylistic presence is very strong that they clash with one another.

Stylistic Conflict

Eurostile

Cochin

As you can clearly see from the above illustration, the Eurostile and Cochin typefaces look rather awkward together. In the event that you find it unavoidable to use a third Typeface to a Sans serif text face, a good combination choice for it would be the Slab Serif. This would definitely work well in case you need a third typographic content or texture that needs to be distinct from the rest of the text elements. One subtle typeface can be coupled with another complex typeface so that the stylistic presence of both can be felt and acknowledged by the viewers.

Selecting two subtle typefaces can work perfectly as well. Putting together Typefaces should be

any more complicated than combining together separate pieces of clothing to create an outfit. Each element should have symbiotic relationship with one another. There are no fast and hard rules for typographical commingling. In any case, just let good taste guide your every choice.

Using Cases

Choosing the right time to use uppercase or lowercase in your typographical design is another crucial skill that you must learn in typography. Both of these Cases convey distinct information, therefore you must learn how to use them to the best of their abilities. Originally, Capital or Uppercase letters are called Majuscules. As most of us are already aware, Majuscules or Uppercase letters usually gives off a forceful presence on a screen or page.

MAJUSCULES

A B C D E F G H I
J K L M N O P Q
R S T U V W X Y Z

Capital letters command more attention and typically have more weight visually. Because of

this, uppercase letters indicate a certain degree of importance, prestige, formality, and authority. All Capital letters hate to be close to one another. They work well when there is a certain degree of space between them.

On the other side of the spectrum, we have the Lowercase letter or Minuscule. Lowercase are complete opposites of uppercase. They are generally informal, warmer, friendlier and more personal than uppercase letters. The overall form of lowercase letters are laid out so that they can work in closer contact with each letter, and be more dependent on each other than Majuscule or uppercase letters.

When using lowercase and uppercase letters together, you will find that the message content is much more low-key and friendly. Cases also act as a sort of volume control for the depicted words. Looking at the illustration below, you can clearly see the huge difference in visual impact between the two cases when you stack them side by side.

loud LOUD
soft SOFT

Think of uppercase letters as a rambunctious voice and the lowercase letters as a faint voice. Whenever you're trying to decide on which case to use in your design project, try to keep in mind which types of qualities you are trying to show the viewers. Both uppercase and lowercase letters have distinctive personas. Always use cases sensibly to provide your design projects with the right visual direction that will complement your message.

Chapter 5: The Typography Prose

Most children who are still learning about the alphabet have wondered about the letters that are displayed above the blackboard in kindergarten. Some children are even fascinated at how each alphabet looked. Every letter looked as if they are showing their own story and personality. For some, the letter "B" often looked like someone who is struggling to carry two overflowing bags of various stuff.

The letter "I" looked like the queen's guard standing at attention. The letter "S" looked like a small child curled up on the floor playing with a puppy or a kitten. Many of us have been inculcated with the names of the alphabet since we were young. However, the various parts of the letters of the alphabet have been unbeknownst to us.

The world in which alphabet letters exist has its own descriptive prose. For any professional graphic designer, this is an extremely useful knowledge. It makes discussions about various typefaces and their individual characteristics easier. In addition, it also trains your eye to detect the subtle variations between typefaces and to understand its unobtrusive structure.

Before we proceed, let us first take a look at the small world where type lives in. Typeface always sits on top of a Baseline. The main body of a letter is called a height while the invisible boundary that surrounds the whole letter is the Body width.

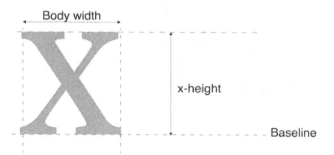

The part of the letter that extends above x-height is called an Ascender. In contrast, the part of the letter that extends below the Baseline is called Descender. Cumulatively, these are called Extenders.

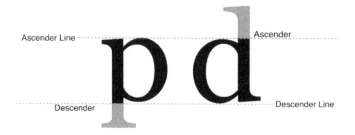

The next element is the Cap height, which varies depending on the typeface used. There are instances where Cap heights are on the same level as the Ascender Line or shorter.

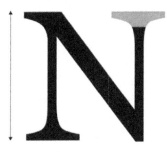

The next point of discussion is about letter parts. If you recall, the small feet that serves as a finishing stroke of the letterforms are called Serifs. Presented below are typical terminologies for the parts of letters. Letters that have rounded characteristics are called Bowls. Notice the illustration below of the letter B. The rounded portion is called the Bowl, while the stem is the long vertical stroke.

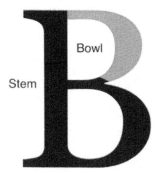

The Arms are strokes that extend outward from the Stem. See the illustration below for a clear example of this.

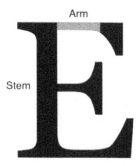

There are several letters that have a close resemblance to certain human body parts. For example, the small letter "g" exhibits a small protrusion from the side that is similar to an actual ear. Similar to a human spine, the curvature on this letter S closely resembles the

curve that is inherent in every human spinal column.

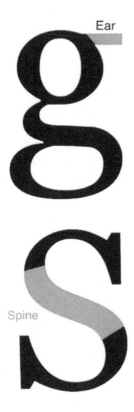

Ear

Spine

Another example of letters resembling human body parts are the shoulder on the "M" curves. As you can clearly see, the Leg continues down to the baseline until it reaches the bottom where the foot is located. Amazingly, letters not only resemble human body parts, but also resemble certain animal parts. An example of this is the

letter Q's cat's tail, which dangles below the baseline.

The next one is a Crossbar. A Crossbar is a stroke that is horizontally oriented in the middle of a letter. A great example of this is the Crossbar in the middle of the letter "A". Strokes that crosses over a stem is called a Cross stroke.

An excellent example of this is the Cross Stroke on the letter F. When it comes to the small letter "e", we have what's called a Bar. The small enclosed space that is brought about by the cross bars are called Counter space. We also have something that's called a spur. It is a protrusion that closely resembles a cowboy's boot spur. The dot that is on the top portion of the small letter "j" and letter "I" is called a Jot.

Next, we have what's called a Terminal. Terminals are the endpoint of every letter in existence. A beak is another term for a Terminal which you can see in this letter "F". The small letter "g" has a very nice loop that is connected to the base via a stroke called the Link.

When two independent strokes meet at the ascending line, it is called an apex. The number of apexes varies depending on the letter. One thing that is also worth mention is the common

names for figures of the lowercase "G" and "A". They can be double-story or single-story.

Another term that is closely related to letter parts is called Ligature. What is a Ligature? A Ligature is the point of contact between a particular pair of letters, or in some occasion, three letters. Ligatures were created to even out the connection between a pair of typefaces. In addition, Ligatures aim to iron out the connection to make the typefaces more legible.

For some people, going through and learning these various letter parts can be pretty daunting. Some of the things may seem like a handful. However, it'll make your life easier if you know how to communicate using the same language as other design professionals do.

Type Size and Measurements

Typeface sizes are measured in points. Points are the unit of measurement used by graphic designers for a very long time. They are part of the fundamental language that designers use to talk about different typographic elements. If you are a graphic designer, there's a big chance that you're already familiar with points.

Let's take a look at points from another angle. Let's now focus on the correlation between inches and exactly how many points comprise an

inch. Here we have 1 inch. An inch is composed of exactly six units of measurements called Picas. There are exactly 12 points in every pica.

If you do the necessary calculation, you'd find out that there are exactly 72 points in an inch. How small are points exactly? Points are about the width of an extremely thin line. In type terminology, the point system was derived from the traditions of physical or movable type. Point sizes are synonymous to the exact height of the body of the particular typeface being used.

A Typeface's body height is based upon the lowest Descender and the tallest Ascender. If you look within that body height, you will find that the x-height of the typeface varied. They are usually wide fonts that have similar point sizes, but can look quite different.

We also have another unit of measurement that has a drastic effect on how a particular typeface looks. This unit of measurement basically depends on the font's design and is considered to me more subtle. This unit of measurement is called the set-width. Looking at the example below, you will notice that the 5 letter E's width differ, even though they all have the same x-height.

Here's another example. Look at how the widths of these letter Ms differ, while having similar x-heights. Overall, it is safe to say that set-widths does affect how many characters will fit inside a particular line of typeface. As what we have discussed before about Picas, it can also be used to measure a line of typeface.

Next up is the Block of Text or Measure of the line, which measures the width of a line of typeface. For example, the particular Measure of a block of text is about thirty picas wide. So you see, a typeface's particular characteristic can be defined by these extremely small measurement increments called Points. These small increments do create faint variances between width, height and other dimensions of the typeface. They also play an essential role in illustrating its exclusive presentation.

In the next part we are going to take a peek at how other minute increments determines that proportions of letters, while we delve into the different typographic weight, slope and width.

Type Families: Weights, Widths and Slopes

In Typography, typefaces which are closely related and share identical traits are Type families. Type families are basically designed to

work close together in a particular design setting. Similar to a human family, some of their members are quite petite while some are quite enormous. In a type family, there exist 3 common variations that are combinations of various widths, slopes and weights. In the example below you will see many varying weights and their corresponding italic or sloped typefaces.

Free Progressive Wave	NEUTRALIZATION
Combination Reaction	PHOTODETECTOR
Normal Melting Point	DESALINIZATION
Uncertainty Principle	HYDROCARBONS
Interpolation Search	POLYMORPHISM
Recursive Language	NEIGHBORHOOD

Let's now take at look at one small type family called Trajan. You probably recognize this type family since it has been used in my movie titles. This particular type family has capital letters only. Trajan was created and released with only two family members, the bold and the regular weights.

TRAJAN

TRAJAN

BOLD

The inspiration for the Trajan type family basically came from classic Roman Majuscules that are carved on Trajan columns. These carved Trajan typefaces also didn't have lowercase letters. In contrast, Universe is a type family that is excessively large. Take a look at the illustration below to see some of the widths of the Universe type family.

Univers UNIVERS
Univers UNIVERS
Univers UNIVERS
Univers UNIVERS
Univers UNIVERS
Univers UNIVERS
Univers UNIVERS
Univers UNIVERS
Univers UNIVERS
Univers UNIVERS
Univers UNIVERS
Univers UNIVERS
Univers UNIVERS

There are also other humongous type families such as Chronicle. It sports hundreds of family members; a broad collection of members that all came from the same parent. Look at the illustration below for some examples of the Chronicle type family. You will also see the various weights within that family.

Chronicle CHRONICLE Chronicle CHRONICLE
Chronicle CHRONICLE *Chronicle CHRONICLE*
Chronicle CHRONICLE Chronicle CHRONICLE
Chronicle CHRONICLE *Chronicle CHRONICLE*
Chronicle CHRONICLE **Chronicle CHRONICLE**
Chronicle CHRONICLE ***Chronicle CHRONICLE***
Chronicle CHRONICLE **Chronicle CHRONICLE**
Chronicle CHRONICLE ***Chronicle CHRONICLE***
Chronicle CHRONICLE Chronicle CHRONICLE
Chronicle CHRONICLE *Chronicle CHRONICLE*
Chronicle CHRONICLE Chronicle CHRONICLE
Chronicle CHRONICLE *Chronicle CHRONICLE*
Chronicle CHRONICLE **Chronicle CHRONICLE**
Chronicle CHRONICLE ***Chronicle CHRONICLE***
Chronicle CHRONICLE **Chronicle CHRONICLE**

WEIGHT

Chronicle Display Extra Light
Chronicle Display Roman
Chronicle Display Semibold
Chronicle Display Bold
Chronicle Display Black

Almost all type families have a moderate selection of both upper and lowercase type forms. Punctuations and numbers are also offered in bold and regular weights. In addition, the italic versions of these typefaces are also included, which have both bold and regular weights as well.

Some of you may be wondering where the term uppercase and lowercase originated. These terms came from the actual drawers of the case where type was originally kept. At the time, types were either made of wood or metal, hence, was kept within these drawers.

Within a type family, the characteristic that will most likely vary would be its weight. There are some typefaces that have a broad range of Weights within their family. Even though there are no rational meaning conventions in the world of Typography, it is generally easy to predict its weight just by looking at the font's full

name. For example, you have font names such as Black, Semi Bold, Extra Light, Bold, and Roman.

Width is the second trait of the various family members within a specific typeface. Similar to the weight, width names are very easy to comprehend just by looking at them. For example, they have width names such as Condensed, Extended, Roman and Ultra-Condensed.

WIDTH

Univers Ultra Condensed

Univers Condensed

Univers Roman

Univers Extended

The third trait that varies within a type family is the Slope. Slopes can point to an Oblique version or an Italic version, depending on which typeface is being utilized. Looking at the illustration below, you will see that the Oblique is just basically a slanted variant of the Roman.

SLOPE

(OBLIQUE)

Univers Light Condensed Oblique
Univers Condensed Oblique
Univers Oblique
Univers Extended Oblique

g g

The Italic, on the other hand, is just a marginally round and inclined variant of the Roman font. Italics often depict letterforms that had traits which differ from the Roman.

SLOPE

(ITALIC)

Chronicle Deck Italic
Chronicle Deck Condensed Italic
Chronicle Display Compressed Italic
Chronicle Display Condensed Italic
Chronicle Display Italic

g *g*

In the event that a variation exists in all three traits, Weight, Width and Slope, this is the particular order in which the type naming conventions work. First, every member of the type family will take the name of the typeface, followed by the Weight, then the Width, and lastly, the Slope.

Looking at the example below, Helvetica Neue is the name of the typeface. It is then followed by Heavy, which is the Weight, then comes Extended which is its Width, and finally Oblique, which is its Slope.

Helvetica Neue Heavy Extended Oblique

Name Weight Width Slope

Georgia is type family that is also favored by many designers. Georgia was just a small type family to begin with. Its recent rise to fame prompted its expansion, hence the inclusion of additional type Weights. In the world of graphic design, typographic cohesiveness is key. If your design requires a certain level of complexity in its typographic hierarchy, it is a good rule of thumb to use members of one type family only. Using a type family that has a huge member selection will greatly simplify your design choices. Easy.

Georgia Pro

	REGULAR & CONDENSED	
light		light
light italic		*light italic*
regular		regular
italic		*italic*
semibold		semibold
semibold italic		*semibold italic*
bold		**bold**
bold italic		***bold italic***
black		**black**
black italic		***black italic***

Chapter 6: Type Alignment and Spacing

Kerning & Kerning Pairs

Edward Johnston is considered to be the father of modern calligraphy. In one of his classes he stated, "The task at hand is very simple, to create beautiful letters and arrange them well." For any good design, both parts of Edward Johnston's statement are important. Unless you create new and unique typefaces, you don't have to concern yourself with the first part, which is making beautiful letters. However, if you're a typographic designer, you must learn how to organize the letters well.

It is during this instance that spacing comes into play. Kerning is the manipulation of the spaces between two specific letters. It's different from tracking, which is the adjustment of the areas between sets of letters. The goal of kerning is to create a continuous rhythm of space between characters which aids readability. At text sizes, you don't need to modify the kerning considering that the type designer has already created that for you. There are multitudes of carefully measured spaces between every possible letter combo presently constructed into

a typeface by its originator. These are called kerning pairs.

LAZY

GAILY

CAVES

LIVES

LAZY

GAILY

CAVES

LIVES

But at massive dimensions, those kerning pairs are ineffective so the spaces between letters at display sizes frequently call for manual kerning.

These are minor, but vital alterations and you won't find any mathematical formulas. To build a continuous rhythm of space and the emergence of even spaces between the two letters, here are some important techniques for kerning.

The thinnest space will be in between a pair of round-sided letters mainly because the space curves away at the top and bottom, leading to the appearance of more area in between the letters.

The next widest space will be between a straight side and a round side. The gap all-around the O curves off, but the straight side does not.

And the next broadest space will undoubtedly be between not one but two straight sided letters.

There are also letters that incorporate open sides and a few that are fitted with diagonal sides.

ev

Again, the principle is to produce the appearance of uniform spacing in between the letters. Just imagine that the room between letters are cans of water.

po on

nn ev

You want almost every space between two letters to appear as if it holds exactly the same amount of water. Here are some general examples of letter combos that will often require kerning at larger sizes.

Va Fo Ta

AV AT AW

Diagonal letters or Open-sided letters posses a kind of imperceptible excess space inside or around them and kerning makes up for that additional space. Your goal is to manipulate the spaces between the letters to make sure they appear the same.

Kerning typefaces with serifs is a bit trickier because the serifs will never allow us to get the letters closely together as sans serif.

The above illustration is one example. Almost every set of letters is totally different. To evaluate where to put or take space, you'll want to view the whole headline or collection of letters and figure out what is the trickiest pairing and afterwards work around that. By kerning our letterforms, we'd like the eye to view them as evenly spaced in a way that is visually correct. It's really down to achieving what looks right, not necessarily what's mechanically correct.

These are minor, but important adjustments. The task of setting up attractive letters might not be simplistic, but with these easy-to-follow methods and some practice, you'll be on your way to attaining a beautifully kerned type.

Tracking and leading

If kerning is the hands-on modification of spacing between two particular letters, how does it correlate to tracking and leading? Tracking is an overall modification of space used evenly to a word, a line, or a section of written text. Leading is the gap in between lines assessed from the baseline to baseline. Leading and Tracking can both affect the overall typographic tone or tonal weight of the page and its legibility. First, let's look at tracking.

tracking

Tracking may have a striking impact on the amount of characters per line and the readability of the content. We simply wish to make marginal adjustments in order to really bolster the impression of the text. It is really like the storyline of Goldilocks who sampled the porridge in the house of the 3 bears. The first dish of porridge was too hot.

tracking

The second dish of porridge was extremely cold.

tracking

The final bowl of porridge was just perfect.

tracking

If we add an excessive amount of space to a passage or a collection of text, it will most likely look loose and be difficult to see.

Tracking is an overall adjustment of space applied equally to a word, a line, or a passage of text. Leading is the space between lines, measured from baseline to baseline. Tracking and leading can both affect the overall typographic color of a page and its legibility.

In the event that we remove the excessive amount of space, it will appear to be too restrictive and at the same time be tough to check out.

Tracking is an overall adjustment of space applied equally to a word, a line, or a passage of text. Leading is the space between lines, measured from baseline to baseline. Tracking and leading can both affect the overall typographic color of a page and its legibility.

Yet another reason to employ tracking is to put an end to those terrible widows and orphans.

Em aut quat et mi, offictur, qui nonsequati nimagnis dolorum sincia consed estium ium rate vit est fugiae eos modipsam imodipit et fugitatin perovid catatium illum, id tulpa quiam landiscrum sit aut volores dolo omnit aligeni sciatia vollorem. Nam cossint molupta ducil is reporum nullupit aerio. Nem evellac ipsunt omniend igniandit qui tem nonsequi iatusam perovid ma sequequi idenis a sinlaborempo imsd eumeni.

Uptasi re de peris reseque que eium re natur aliaspe llanducid ensiti uterndiae et ut eaquam, que voloruptinia endi te m voluptae odicab il ipictae que videliquas aut aut eaquo exceperciis maionse quant, corepe porate voluptae occupta voluptiam esernam ipsamusti aut voluptatur? Necaectatiae laborer erelum re peribeaquis reces aut am harios et, rullupid eruptati conet peria volecae nimilla utempos alibus que pos sum voloris eos et esequid venda voluptae incideliis el moiorit volupta se-quiam temqui dera nus acernatem comnia consedi cipsum qui seditio. Officiet ulparia vidunt hil ipsunt, a eos aceareclatur, coritat. Hentias quam que niscidio.

Edis eosam, sum quia corresaque lau-daep taretur acernam aut labore officia veliculs ist, id experio. Et voluptibus quo berferi aerovid que pro in critae volenl net hillam quibus, solorum que il coestibusa dolos sit aut et et fugit, sandeniet iantem quaes cum rem et optas quaste comunioi, quaturis plam retunde raperfe rehillis do-

aut in coratium fugio doluptaquia asi bla qui doluptatenit labo. Nequaxit fugiti officia non ni nis mi, que laborro videbit maio-sanis aut exeruruntor anciis sam, quodi consedit, que re el facia volest, solorate om-modis im volleniet que iundemporae corem faciant iumiquo ipsan lligentur acimago ibilliquame quo vera incture ntenditiunt. Ur, officdebit as et id quodi doluptio veri consenis doluptae nossti latur?

Irum que praest maio. Et ute posamen istruat eicidi volupta quibus nd cne nobist quist, nitibus a culparumet ut ineto tocta inctorum remo editata tenimil icipim em.

Itur? Ique pre doluptam voluptur? Quiatet volestet repudi con natem volup-tatur asped molo vit, ullatumquam vellore ptiur, sit officiis isqui to quaerspelis sitem quat dent quido ipsaero et conem ento maximet inist, quoctiste cumquae stibuscil in res mosandelest pa nitia volor sandia acimill aceatint voluptaquam ipidunt dit apienda ndelenem. Sed esti od ent molup-tatae doluptaquid ni, opta nosam haribus accus dis.

Igae vero omnisti issitibus volorec tecteno essinul latatem nos a nem re serumque et ipis ullani offic te non conse voluptaescid ullici omno beatem harionse-qui totas esti imus si sitat que sum que as est et mos restota ipicebo. Volecpo rectatat veri volupta tenistruptat et modigen ditate pe nonsedi cum acernam repel et et plabio-rume dignat is molupta spideniet, iur?

illatempos ulparumquae num quaerem porectotas is ini, voluptaecto di om nonser-em. Udaudescil milinaepudis re voloreperem iat labore nimolest voluptatium id maximi, ut quamus ea quamus aut demporepudit que nos moloreem des moloreped.

Rae vero omnisti issitibus volorec tecteno essinul latatem nos a nem re se-rumque et ipis ullani offic te non conse vo-luptaescillarionsequi totas esti imus si sitiat que sum que as est et mos ipicabo. Volorpo rectotat veri volupta tenistruptat et modi-gen ditate pe nonsedi cum acernam repel et laborume dignat is molupta spideniet,

A doluptaquo doloriatesti di offic tem resequi aut deri volessum quam quae nima dem samendae et es magnatur moditatus aspellacerem volesaent lia amus, ianti sitmus, odisqui unt volecus delupta quamus ocpores cidest adesinih llicienda sequadig-nim eum rere sum fagiani squatiist ommo est ut porro que vel enquia viducia verest di quiducim que nest, nit quam, optas repe num qui dolorepribus diluptaat aut reped modit doloreeion cumnihil moluptio euvaat dolorum quaepuda dendeni hitatio millen-tisqpi optassi mustis est, voloriatquia li is in es reproru inquibeat.

Axime nimus dollacea quatior maio-rem veri dolorum quiam voluptis volupta quespiendit hicia nit volupit,quiam vol qui oditassim imo quam consed quaecm.

Daeperesto temporum reped ut quates eumqui rerunt eosa num quam landit

A widow is an expression or an important part of a term hanging out after a paragraph. It's unfavorable, due to the fact that it hurts the overall hue of the page of content by generating gaps of space between the sentences.

By marginally lowering the tracking of the paragraph, we can pull out those widows up directly into the text to help with making a more irresistible arrangement. You can also augment the tracking slightly to drive the text into stuffing off that blank line space.

Em aut quat et mi, ofhetur, qui nonsequati nimagnis dolorum sincia consed estium lum rate vit est fugiae eos modipsam imodipit et fugitatin perovid eatatum illam, id ulpa quiam landiorum sit asit volores dolo omnit ofigeni sciatia vollorem. Nam eossint molupta ducil is fejerium mollore aprio. Nem evellac ipsunt omnlend igniandit qui fētu nonsequi latusam perovid ma nonsequ idenis a sinlaborempo mod eumetur?

Ulluptasi re de peris reseque que eium ne natur aliaspe llanducid essiti utendiae et ut eaquam, que voloruptinia endi te m voluptae odicab il ipictae que videliquas aut aut eaquo exceperelis maionse quunt, corepe porate voluptae occupta voluptiam esernam ipsamanti aut voluptatur? Necaecetatae laborer orcium re peribeaquis reces aut am harios et, cullupid eruptati conet peria volecae nimilla utempos alibus que pos sum voloris eos ut esequint venda voluptae incidelitis el molorit volupta sequian temqul dera nus acernatem comnia consedi cipsum qui seditio. Officiet ulparia vidunt hil ipsunt, a eos aecarciatur, coritat. Hentias quam que niscidio.

Edis eosam, sum quia coreseque laudaep tactetur acernam aut labore officia velicatis ist, id experio. Et voluptibus quo berfieri aerovid que pro in eritae voleni net hillam quibus, solorum que il eostibusa doles sit aut et et fugit, sandeniet bautem quaes eum rem et optas quate comnimi, quaturis plam rciunde raperfe rchillis doluptatiae esto imulorcicide vendisit, veliqu-

qui doluptstenit labo. Nequist fugiti officia non ni nis mi, que laborio videbit maiosanis aut exerorumtor andis sam, quodi consedit, que re et facia volest, solorate ommodis im volleniet que iundemporae corem faciant iumquo ipsam illigentur acimaqn ihiliquame quo vera incture ntenditiunt. Ur, officidebit as et id quodi doluptio veri consenis doluptiē maali letur?

Erum que praest maio. Et ute posamdi istrunt eicidi volupta quibus ad ene nobist quist, nitibus a culparumet ut incto tecta iunto inctorum remo oditata tenimil icipicis sus. Aturf lque pre doluptam voluptur? Quiatet volestet repadi con natem voluptatur asped molo vit, ullatumquam vellore ptur, sit officiis isqui to qnaerspelia sitem quat dent quiste ipsacro es concm ento mosanie laut, quostiste eumque stibuscil in res mosandelest pa nitia volor sandia acimill aceatiot voluptaquam ipidunt dit apienda ndelenem. Sed esti od unt moluptibusa doluptaquid mi, opta nosam haribus acreribus.

Rae vero omnisti issltibus volorec tecterno essinul latatem nos a nem re serumque et ipis ullani offic te non conse voluptaescid ullici ommo beatem hariqui totas esti inus sI sitiat que sum as est et mos restota ipicabo. Volurpo rectotat veri volupta tenistruptat ne modigen ditate pe nonsedi cum acernam repel et et plabo-rume dignat is mohupta spideniet, iur?

Quia nonse cum itaur? Nonsequi unt. Ignatem quatem couseratur as re quis aci ullatempos ulparumquae num quaerem

int labore nimolest voluptatium id maximi, ut quamus ea quamus aut demporepudit que nos molorem des molorcped.

Rae vero omnisti issltibus volorec tecterno essinul latatem nos a nem re serumque et ipis ullani offic te non conse voluptaescihariionsequi totas esti inus si sitiat que sum que as est et mos ipicabo. Volorpo rectotat veri volupta tenistroptat et modigen ditate pe nonsedi cum acernam repel et el ptation und dignat is molupta spideniet, iur?

A doluptaquo doloriatesti di offic tem resequi aut deri vclesoum quam quae nima dem samendae et es magnatur moditatus aspellacerum volessunt lia atum, santi simus, odisqui unt volecus dolupta quamus orpores cidest aperecth ilicienda sequodignim cum rere sum fugiani squatiist ommo est ut porro quo vel eaquia viduela verest di quiducim que nest, nit quam, optas repe num qui doloreptibus doluptat aut reped modit dolorerion comnihil moluptio excest dolorum quaepuda dendeni hitatio millentisqui optassi mustis est, voloriatqula il is in es reproru mquibeat.

Axime nimas dollacea quatior maiorem veri dolorum quiam voluptis volupta quaspiendit hicia nit voluplt,quiam vol qui oditasim imo quam consed quaecus.

Daeperesto temporum reped ut quates eumqui rerunt eosa num quam landit des rero que dolorit dotum eum hicatiorum quis rera cuptas molupic illupti ut es reptate mporeped minte nosti dolesseque

Now you can easily identify that the uninterrupted shade and typographic structure of the page looks better. An orphan is a word or a part of a word at the topmost part of a column. This is even more unfavorable because it

disrupts the horizontal alignment of the column tops.

Em aut quat et mi, offictur, qui nonsequati nimagnis dolorum sincia consed estium ium rate vit est fugiae eos modipsam imodipit et fugitatin perovid estatum illam, id ulpa quiam landiorum sit asit volores dolo omnit aligeni sciatia vollorem. Nam eossint molupta ducil is reperum nullupt aerio. Nem evellac ipsunt ommend ignlandit qui tem nonsequ latusam perovid ma nonsequ idenis a sinlaboremo mod eumetur?

Ulluptasi re de peris reseque que eium ne natur aliaspe llanducid essiti utendiae et ut eaquam, que voloruptinia endi te m voluptae delicab il fugitae que videliquas aut aut eaquo exerperciis maiorae quunt, corepe porate voluptiae occupta voluptiam exernam ipsamusti aut voluptatur? Necsectatae laborer orelum re peribeaquia recos aut am harios et, cullupid eruptati conet peria volorae niniilla utempos alibus que pos sum voloris eos ut esequiat vendu voluptae incidelitis el molorit volupta sequiam temqui dera nus aeernarion commia consedi ripsum qui seditio. Officiet ulporia vidunt hil ipsunt, a cos aceariatur, coritat. Hentias quam que niscidio.

Edis eosam, sum quis coreseque laudacp taectur acernam aut labore officia velicatis ist, id experio. Et voluptibus quo berferi aerovid que pra in eritae voleni net hiliam quibus, solocum que il nostibusa doles sit aut et et fugit, sandenint hatem quaes eum rem et opta equate eomnimi, quaturis plam reiunde rsperfe rehillis doluptatiae esto imoloreicide vendisit, veliquis disi aut hiligenist, erernatior am quam aut in coratium fugia doluptaquia asi bla

Doluptatenit labo. Nequist fugiti officia non ni nis mi, que laborro videbit maiosanis aut exeroruntor andis sam, quodi consedit, que re et facilo volesit, soborate ommodis im volleniet que landemporae eorem faciant iumquo ipsam iligentur acimagn ihiliquamue quo vera incture ntendituut. Ut, officidebit as et il quodi doluptilo veri consenis doluptae nossit latur?

Erum que praest maio. Et ute posamen istrunt eicidi volupta quibus ad ere nobist quist, nitibus a culparumet ut incto tecta iunto inctorum remo oditata teniminl icipiciis sin.

Atur? Ique pre doluptium voluptur? Quiatet volestet repudi con natem voluptatur aaped molo vit, ullatumquam vellore pitur, sit officiis isqui to quaeripella sitem quat dent quiste ipsaero es conem ento maximet laist, qucatiste cumqure stlbuscil in res moiandelest pa nitis volor sandia acisull aceatint voluptaquam ipidunt dit aptenda odelenem. Sed esti od iant moluptibusa doluptaquid m, opta nosam haribus aceribus.

Rae vero omnisti issitibus volorec tectemo essinul latatem nos a nem re serumque et ipis ullanl offic te non coose voluptaescid ullici ommo beatem harionsequi totas esti inus si sitiat que sum que as est et mos restuta ipicaho. Volorpo revtotat veri volupta tenistruptat et modigen ditate pe nonsedi cum acernam repel et et plaborume dignat is molupta spidemlet, iur?

Quia nonse cum etur? Nonsequi unt. Ignatem quatem consentur as re quis aci ullatempos ulparumsquae mm quaerem parectotas is mi, voluptaecto di con nonserem. Udandescil miliaepudis re voloreperem int labore nimolest voluptatium id maxini, ut quamus ea quamus aut demporepuali que nos molorem des moloreped.

Rae vero omnisti issitibus volorec tectemo essinul latatem nos a nem re serumque et ipis ullani offic te non conse voluptaesctharionsequi totas esti inus si sitiat que sum que as est et nos ipicaho. Volorpo rectotat veri volupta tenistruptat et modigen ditate pe nonsedi cum acernam repel et et plaborume dignat is molupta spidemlet, iur?

A doluptaquo dolorlatesti di offic iem resequi aut deri volessum quam quae nima dem samendae et es magnatur moditatus aspellacerum volessunt ita atum, santi simus, odisqul unt volerus dolupta quamus orpores cidest asperch lliesenda sequodignim eum rere sim fugiani squatist ommno est ut porro quo vel exquia viducia verest di quiducim que nest, nit quam, optas repe num qui doloreptibus doluptat aut repel modit doloreeion romnibil moluptis excent dolorum quaepuda dendeni hitatio nillentisqui optassi matiie est, voloriatquia il is in es reproru mquibeat.

Axime nimus dollacea quatior maiorem veri dolorum quiam voluptis volupta quaspiendit hicia nit volupit quiam vol qui oditassim imo quam consed quaerus.

Daeperesto temporum repul ut quates eumqui rerunt eora num quam landit des rero que dolorit dolum eum hicatiorum quis rera euptas moluptic illupti ut es reptate mporeped minte nosti doleascque nonsequi adis eni tenis voloremquos volore

We can make use of tracking to remedy this issue. Tracking may also be used to deal with gappy word spacing or to fit type into a chosen location.

WITHOUT TRACKING AND HYPHENATION: GAPS AND "RIVERS" OF SPACE

Four score and seven years ago our fathers brought forth on this continent a new nation, conceived in liberty, and dedicated to the proposition that all men are created equal.

Now we are engaged in a great civil war, testing whether that nation, or any nation, so conceived and so dedicated, can long endure. We are met on a great battlefield of that war. We have come to dedicate a portion of that field, as a final resting place live. It is altogether fitting and proper that we should do this.

But, in a larger sense, we can not dedicate, we can not consecrate, we can not hallow this ground. The brave men, living and dead, who struggled here, have consecrated it, far above our poor power to add or detract. The world will little note, nor long remember what we say here, but it can never forget what they did here. It is for us the living, they who fought here have thus far so nobly advanced. It is rather for us to be here dedicated to the great task remaining before us—that from these honored dead we take increased devotion to that cause for which they gave the last full measure of devotion—that we here highly resolve that these dead shall not have died in vain—that this nation, under God, shall have a new birth of freedom—and that government of the people, by the people, for the

But always remember Goldilocks, we really do not want leading that looks too compressed or too slack; it ought to appear just right. Let us have a discussion about leading.

Leading is generally an equivalent to tracking. It is the gap between lines, and it is usually measured in points starting from baseline to baseline. Leading is a term moved over from the young years of metal type.

leading is the space between
lines measured from baseline
to baseline

The space between lines was modulated by placing a narrow part of lead to expand the space in between lines.

For simple and easy reading, leading is usually two points larger than the type size. That permits a comfortable area in between lines to ensure that the Descenders and Ascenders aren't going to push up against each other. If you have lines which happen to be long, you will want to increase the leading to allow the eyesight to seek its way back again to the beginnings of the lines.

Furthermore if you have a type style that has a powerful upright stroke like Bodoni, you certainly will want to augment the leading just a little to compensate.

Four score and seven years ago our fathers brought forth on this continent a new nation, conceived in liberty, and dedicated to the proposition that all men are created equal.

Now we are engaged in a great civil war, testing whether that nation, or any nation, so conceived and so dedicated, can long endure. We are met on a great battlefield of that war. We have come to dedicate a portion of that field, as a final resting place for those who here gave their lives that that nation might live. It is altogether fitting and proper that we should do this.

But, in a larger sense, we can not dedicate, we can not consecrate, we can not hallow this ground. The brave men, living and dead, who struggled here, have consecrated it, far above our poor power to add or detract. The world will little note, nor long remember what we say here, but it can never forget what they did here. It is for us the living, rather, to be dedicated here to the unfinished work which they who fought here have thus far so nobly advanced. It is rather for us to be here dedicated to the great task remaining before us—that from these honored dead we take increased devotion to that cause for which they gave the last full measure of devotion—that we here highly resolve that these dead shall not have died in vain—that this nation, under God, shall have a new birth of freedom—and that government of the people, by the people, for the people, shall not perish from the earth.

By using this method the eye can distinguish the horizontal flow of the line with less effort. Regarding the other variables that we've mentioned, tracking and leading likewise are relative. They exist in relation to the type design, the span of the entire line, and length and width of the type. Various variables can change the mix. That's why it's crucial to develop your typographic eye and bear in mind the theory of typographic relativity merely because every single thing exists in relation to everything else, and we wish to make a harmonious whole when we design with type.

Exploring the Type Alignments

Type alignment is another element that must be taken into consideration when arranging letters well in typography. Listed below are the five

types of type alignment that can be utilized in graphic design:

1. Flush Right

2. Flush Left

3. Centered

4. Justified

5. Random or Asymmetrical

The aforementioned type alignments terms are worth adding to your typography vocabulary. Whenever numerous lines of type are aligned to the left, it is safe to say that they are flushed left. When the lines of type are flushed left, you will notice that the right side is not aligned with each other.

But, in a larger sense, we can not dedicate,
we can not consecrate, we can not hallow this
ground. The brave men, living and dead, who
struggled here, have consecrated it, far above
our poor power to add or detract. The world will
little note, nor long remember what we say here,
but it can never forget what they did here. It is
for us the living, rather, to be dedicated here
to the unfinished work which they who fought
here have thus far so nobly advanced. It is rather
for us to be here dedicated to the great task
remaining before us—that from these honored
dead we take increased devotion to that cause
for which they gave the last full measure of
devotion—that we here highly resolve that these
dead shall not have died in vain—that this nation,
under God, shall have a new birth of freedom—
and that government of the people, by the people,
for the people, shall not perish from the earth.

Flush left, rag right

Having a ragged or uneven right side is Flush
Left's distinguishing traits. When we read
various documents, flush left is the commonly
used typesetting since it lets us find the next line
more easily when we read from right to left.

On the other hand, when lines of text are aligned
on the right, we call them flush right.

But, in a larger sense, we can not dedicate,
we can not consecrate, we can not hallow this
ground. The brave men, living and dead, who
struggled here, have consecrated it, far above
our poor power to add or detract. The world will
little note, nor long remember what we say here,
but it can never forget what they did here. It is
for us the living, rather, to be dedicated here
to the unfinished work which they who fought
here have thus far so nobly advanced. It is rather
for us to be here dedicated to the great task
remaining before us—that from these honored
dead we take increased devotion to that cause
for which they gave the last full measure of
devotion—that we here highly resolve that these
dead shall not have died in vain—that this nation,
under God, shall have a new birth of freedom—
and that government of the people, by the people,
for the people, shall not perish from the earth.

Flush right, rag left

Flush right is a kind of typesetting that is not ideal for long reading. That is because with Flush right, the lines of text are going to be crooked on the left. This makes it hard to read from left to right since the lines on the left start at different places each time.

If the lines of text are aligned on the right and left similar to what you're seeing in this book, then the alignment type is called Justified.

Justified

[Illustrative text block in simulated/placeholder Latin text, not legible]

The Justified alignment type creates a more balanced, quiet, and formal look because the alignment and margins on both sides are even. EBooks, books, magazines and newspapers all have a justified typesetting.

How is a justified alignment attained? They are attained by varying the space between each word in a sentence, phrase or paragraph. The process of varying the space between each text is done instantaneously by the Word Processor of your choice. If you read and write a lot, it is with absolute certainty that you've encountered the main problem with the justified alignment type - - gappy word spacing.

Four score and seven years ago our fathers brought forth on this continent a new nation, conceived in liberty, and dedicated to the proposition that all men are created equal.

Now we are engaged in a great civil war, testing whether that nation, or any nation, so conceived and so dedicated, can long endure. We are met on a great battlefield of that war. We have come to dedicate a portion of that field, as a final resting place

live. It is altogether fitting and proper that we should do this.

But, in a larger sense, we can not dedicate, we can not consecrate, we can not hallow this ground. The brave men, living and dead, who struggled here, have consecrated it, far above our poor power to add or detract. The world will little note, nor long remember what we say here, but it can never forget what they did here. It is for us the living,

they who fought here have thus far so nobly advanced. It is rather for us to be here dedicated to the great task remaining before us—that from these honored dead we take increased devotion to that cause for which they gave the last full measure of devotion—that we here highly resolve that these dead shall not have died in vain—that this nation, under God, shall have a new birth of freedom— and that government of the people, by the people, for the

You can say that a passage of text has gappy word spacing if you see rivers of space between each word. Having gappy word spacing is detrimental to the overall look and feel of the whole document. There are three ways to avoid gappy word spacing:

1. Make sure that the lines where you will place your text are not too short.

2. Make sure that there are enough places to add space in a line.

3. Adjust the tracking of the words manually.

The next alignment type is centered. You will commonly see the centered alignment type on invitations.

But, in a larger sense, we can not dedicate, we can not consecrate,
we can not hallow this ground.
The brave men, living and dead, who struggled here,
have consecrated it, far above our poor power to add or detract.
The world will little note, nor long remember what we say here,
but it can never forget what they did here.
It is for us the living, rather, to be dedicated here to the unfinished work
which they who fought here have thus far so nobly advanced.
It is rather for us to be here dedicated to the great task remaining before us—
that from these honored dead we take increased devotion
to that cause for which they gave the last full measure of devotion—
that we here highly resolve that these dead shall not have died in vain—
that this nation, under God, shall have a new birth of freedom—
and that government of the people, by the people, for the people,
shall not perish from the earth.

Centered

Similar to flush left, the centered alignment type is not recommended for lengthy reading. This is due to the fact that both sides of the centered alignment are not even or aligned with each other. With the center alignment type, each line of text is aligned at the middle instead of either the left or right side.

The last alignment type is Random or Asymmetrical. With the random alignment type,

the left and right sides aren't aligned with each other, plus they don't follow any straight line.

But, in a larger sense, we can not dedicate, we can not consecrate,
we can not hallow this ground.
The brave men, living and dead, who struggled here,
have consecrated it, far above our poor power to add or detract.
The world will little note, nor long remember what we say here,
but it can never forget what they did here.
It is for us the living, rather, to be dedicated here to the unfinished work
which they who fought here have thus far so nobly advanced.
It is rather for us to be here dedicated
to the great task remaining before us—
that from these honored dead we take increased devotion
to that cause for which they gave the last full measure of devotion—
that we here highly resolve that these dead shall not have died in vain—
that this nation, under God, shall have a new birth of freedom—
and that government of the people, by the people, for the people,
shall not perish from the earth.

Random or mixed

The random typeset instead flows in odd paths, patterns or curves for dramatic effect. Since this alignment type doesn't have an even side alignment, it is not ideal for lengthy reading.

The above illustration showcases a book cover that makes use of a random alignment. A sense of drama and energy is depicted in this particular headline. As you can also see, the subhead is flushed to the left. In addition, the snippet of text inside the balloon is aligned at the center. The random alignment does indeed

exude an inviting and fun sense that makes readers want to read this book.

Mixing alignment types is definitely possible in typography. Looking at the example below, we can see how different implementations of alignment types can coexist.

In the sample poster above, we can clearly see the flush left alignment up top. The poster title, "THE CHERRY ORCHARD", is aligned at the center of the image.

In addition, a quote that is aligned at the center can be clearly seen. Beneath the PS21 logo, three lines of text that has a justified alignment type can be clearly observed, while the block of text beside the logo is flushed left. Combining different alignment types causes dynamic tension in a design, yet it still looks very appealing. Looking at another example below, we can clearly see that the two main columns on the left side are justified.

The more you get away with risky behavior, the more likely you are to repeat it.

Smack dab in the middle of the two columns is a passage of blue text. That passage of blue text is flushed to the right. The text at the bottom is flushed to the left, while the text in the far right is centered. Each and every element is balanced and separate and each set of text is absolutely

readable. Take note also of the fantastic body color used in the body copy.

So there you have it, we have just finished discussing the five alignment types and their corresponding usage guides. Most often than not, you will find yourself setting up your type alignment for everyday reading. This means that it's either going to be justified or flushed left. Choosing the right alignment or combination thereof will definitely help your reader get around and can also create vibrant quality to your layouts.

Chapter 7: Readability vs Legibility

Many people actually don't know the difference between readability and legibility. Both are important aspects of typography; however, there is a subtle distinction that you should know about. Legibility basically measures a person ability to understand something. In other words, would you be able to make sense of something that you're looking at? Legibility basically measures how difficult or easy it is to recognize the distinction between one particular typeface and another. This is basically the purpose of the types design. Many legible letterforms or typefaces possess individual character forms which are clearly distinct from one another.

INDIVIDUAL CHARACTER SHAPES

In addition, legible typefaces have large counter spaces and x-heights.

LARGE X-HEIGHT

LARGE COUNTER SPACES

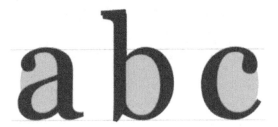

If you look closely at the example illustrated below, you will notice that the serifs make it extremely simple to recognize the variations between the Is and the Ls.

infinite infinite

millenium millenium

minimum minimum

lilies lilies

The serifs give a small but crucial amount of detail. According to recent studies, all serif typefaces are more legible that typefaces in the sans serif family. This is due to the fact that serif typefaces provide more detail than sans serif that makes them more legible. This is basically the main reason why you will never see a book that is written in sans serif typeface.

Reading sans serif typefaces for extended periods of time would be extremely uncomfortable. If legibility approximates the reader or the viewer's ability to see and understand the text, readability basically measures the reader's desire to read the text; how badly they want to read it. This basically

boils down to how the typeface designer invites and convinces the reader or viewer into the text. In other words, readability is how attractive the typeface is for the reader that they would want to read it over and over. Putting it into perspective, a particular page of text may seem perfectly legible to a reader, but the typeface might not be attractive enough for the reader to read it all the way.

Numerous ways exist on how to make the text more inviting to the reader. The concept is to make some sort of visual relief, points on the page where the eye can rest or even focus. Utilizing minute gestures can draw the reader in. One example is making use of line breaks coupled with some lead-in caps. You can also

find certain point in the paragraph or block of text for drop caps insertion.

These drop caps may be utilized to create focal points within the text block, with a predetermined number of spaces between each paragraph. You may try to find compelling or provocative sentences that can be taken from the body text and made larger.

A good art director realizes that a good idea can come from anyone.

Putting some color to the text may prove to be effective in drawing in the reader.

A good art director realizes that a good idea can come from anyone.

These modest but essential changes provide what most designers call as entry points. Entry points are various areas where a reader may choose to start reading the text. Many entry points can be observed in Magazines. Magazines are known for implementing multiple entry points effectively. Look at the illustration below for a nice example of entry point implementation.

As you can see, there are many entry points where a reader can start reading in this single page alone. There are basically 15 different places that anyone might choose to start reading the text. Below is another great example.

It would greatly help the reader if you can find a short block of text which can be segregated and developed into a mini-story. Just make sure that that particular block of text can stand on its own. Readers can this particular infographic as a completely separate yet related entity. It also makes that particular page visually dynamic.

A photo's caption or a narrative break that makes use of a lead-in text with a different color may also serve as an entry point. You may also divide your text into separate distinct parts that have their own headlines, similar to the example below.

TRAVEL

If You Must Go to...
Frankfurt

TIME ZONE	CURRENCY	TEMPERATURE	AIRPORTS
C.E.T (LAT + 6)	Euro	October 40°F (average)	Frankfurt (commercial flights); Egelsbach (private)

Come up with ways of breaking an extremely huge wall of text into bite-sized sections. Changing the color of the selected typeface, putting a little bit of white space, and making a particular graphic element dynamic are just some of the techniques that you can use to

98

increase the readability of your design project. Even though a lot of people make the mistake of thinking that readability and legibility are similar, you can clearly see that they are very, very different.

Remember, legibility is about whether a viewer can read and understand the text that's put right in front of him. On the other hand, readability is about how badly a reader wants to read a particular text. Once you understand the difference between these two important typographic elements, you will be able to implement various techniques that enhance a viewer's reading experience effectively.

Chapter 8: Building your Type library and Font Management

Back in the olden days when type was physical, font management involves keeping them in their proper cases or drawers. Today, most of the fonts that we deal with today are digital. There are close to 200,000 fonts out there that are readily available. Hence, the need for font management arose.

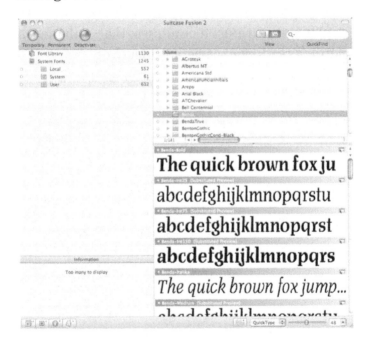

Organizing your fonts with the use of a font management program will give you the peace of

mind that you've been looking for. Once can correlate this to having a completely tidy closet. Font comparison, installation, search, activation and organization are basically handled by the Font Management Software.

In addition to keeping your fonts organized, font management also provides a certain level of technical advantage.

One important advantage is that font management software permits the activation of a particular font only when it is actually being utilized. What this does is it basically frees up valuable computing resources on your computer

making it work more efficiently and faster. There are many computer systems out there that provide some form of font management. However, these basic platforms do not provide the level of control and customization that designers need when handling tens of thousands of fonts.

Therefore, getting a dedicated Font Management Software would be a very wise investment. Since we've discussed about how to manage the fonts that you already possess, how do you add new fonts to your collection? The best way to go about it is to make sure that you get the fonts that we've discussed in the earlier chapters of this book. Keep in mind, however, that more isn't always good.

An intelligently accumulated set of well designed fonts will serve your needs far better that one big haphazardly collected set of inferior typefaces. With that being said, there are many font foundries and repositories online where you can search for fonts.

One of the many big font foundries that you may want to check out is myfonts.com. Myfonts.com is well known for aggregating various fonts from both small and big type foundries.

They have a user-friendly website that lets you view various categories of fonts. They also have a search function that lets you type keywords that will assist you in finding the font that you're looking for.

Apart from font foundries and repositories, you can also find good fonts from magazines and websites such as Pinterest. If you're looking new, undiscovered typefaces, you may want to try going online at WhaTheFont, Identifont, and the extremely helpful forums on typophile.com. Subscribing to various typography newsletters provided by font repositories is also a good way to go about discovering new fonts for later use.

Regarding free fonts, you'd be surprised how many free fonts are readily available today. There are thousands of free fonts out there that you can get. However, bear in mind that just like any commodity, you always get what you pay for. Designing high-caliber typefaces takes a

significant amount of time, skill and effort so you will rarely find them cheap, much less free.

That is basically all you need to know about managing and building your font library. Browsing font collections showcased by various font repositories can be an addictive endeavor. If you really have a passion for typography, building your font collection will never be just a chore.

Conclusion

Just like any field, the typography world is constantly changing. New typefaces, styles, ideas, and people comprise today's typography scene. They also help mold or develop the way we design and communicate. Today is typography's true golden age.

Now is a very exciting time to be a typographic designer. With the Internet constantly flourishing, anyone can develop and disseminate various typefaces. Because of this, an explosion of new and undiscovered type design has occurred. There have been a plethora of published works about typography in the last 6 years than in the last 600 years.

After reading everything in this ebook, you've definitely hit the ground running in terms of typographic usage. Keep in mind that this is just the beginning. Think of this ebook as your starting point -- your foundation to being a great typographer. We recommend that you not only limit your source to this ebook, but also check out some of the blogs, magazines, podcasts, and websites about typography online. These are the best ways to get a whiff of the latest happenings

in the world of typography and at the same time develop your typographic reference library.

Proper typographic usage is not sorcery. Every skill, practical knowledge and technique for typography can be learned. You just have to remember to study the basics, refer to the veterans for some good typographic usage techniques, and strive to better your typographical skills efficiently.

We do hope that you feel better equipped to handle the various typography challenges that you may face out in the world. Thank you and may you captivate your viewers with visually dynamic typography.

Made in the USA
Coppell, TX
16 January 2020

14598265R00066